Cultivate A
CrEaTiVe
Mind

A Guide To Regain Creative Confidence

Simón Silva

CULTIVATE A CREATIVE MIND

10 9 8 7 6 5 4 3 2

Copyright © Simón Silva, 2014

Selections from this book first appeared on the author's
Web site, www.simonsilva.com

Printed in the United States of America

Set in Adobe InDesign
Designed By Simón Silva

A GUIDE TO REGAIN CREATIVE CONFIDENCE

*This book is dedicated to my wife, my kids and
to everyone that I've met that has inspired me!
You know who you are!*

*"Creativity helps us fight off the
monotony of everyday life!"*
– Simón Silva

Preface

Having been in the art field for 18+ years, I have seen first hand the continued disrespect towards the arts in our society/education system. Art classes are being dismantled, treated like baby sitting classes, or simply eliminated in many school districts. All of this is adding to a growing disregard for the arts, which is something incredibly important.

As an artist, I had the desire to bring about a renewed interest and respect for the arts for everyone regardless of race, gender, or social status. My desire was to help individuals understand the importance of the arts and what the arts are able to offer us. I knew that the arts carried the key to creating change in people's lives. Changes that can affect our society economically, socially, and creatively. A good example of this would be the fact that an entire generation of engineers were inspired to get us to the moon after viewing Saturday morning cartoons and Sci-fi movies.

I'm not an academic and I don't claim to be one. The structure of this book is simply a compilation of my experiences as an artist/instructor and what I've encountered hosting workshops throughout the country. The content and language structure of this book is an honest and simple

presentation of what has worked to help individuals regain creative confidence.

There's a big difference in being creative and being talented: a creative person shows us something new, a different way of looking at things. A talented person shows us things exactly as they appear.

I used to think that art was about copying things, making things appear photo realistic. In doing this I received a great deal of praise from my teachers because what I created looked just like the subjects I was drawing or painting. This was my talent not my creativity that my teachers were praising. It wasn't until I began to incorporate my personal interpretation and tried to express creativity through my artwork that I crossed over from being talented to creative.

Eighteen years ago I was invited to speak to a group of "At Risk Students" in downtown Los Angeles and it was almost a complete failure. The only thing that was successful at the time was my honesty. It was at this presentation where I began my creative journey. My communication skills were limited but I was determined to somehow accumulate as much information to create a change in people's lives, including mine.

This book is just that, an accumulation of projects and

concepts that have worked over the years. My workshops have re-nurtured the creativity of individuals of all ages and has also nurtured my own.

Sadly, I continue to come across adults as well as students as young as second grade, responding to the art projects that I assign to them with alarming fear and doubt. Most students that I work with are incredibly worried about grades, testing, and the approval of others, which has caused them to build up their fear. This fear will continue to build up and by the time they become working professionals, they will be limited in their creativity and curiosity.

Students, whom a few years earlier, were writing on the walls, mixing things, creating funny noises, exploring and seeking out the "wow" factor, are no longer curious or creative. It is my hope that this book helps many to recover what they have lost, an abundance of curiosity and creativity!

Introduction

Someone asked me an amazing question recently; they asked me if I had always been this intelligent as a kid. I was immediately struck by the depth and creativity of the question. I wanted to answer this person as honestly and as intelligently as I could, so I thought deeply about my answer. I envisioned myself as a 10 year old and I saw a child with lots of ideas, thoughts, and feelings. At that age the only thing holding me together was my artistic talent. I provided cheap labor for my teachers creating bulletin boards and free drawings for friends.

I did have a desire to speak out and show the world what was going on in my head but I didn't know how. I just hadn't developed the communication skills required for me to show people how intelligent I really was. My answer to this person was, "yes." I had always been incredibly smart, but I was limited by my inability to communicate effectively. I had a platform with my art but my skills were centered in my ability to draw great looking drawings for my friends and family. It was the wonderful introduction to books, that I could relate to, that provided me with the liberty and the desire to communicate through my paintings and my stories. I wanted

to make a difference in the world!

Since that question I've come to understand that we're all incredibly intelligent. Your kids or your students are incredibly intelligent. All they need is a platform; a means to communicate their thoughts clearly. They also need to continue to nurture their communication skills so they can show the world their amazing intelligence.

I tell all of my students that the only difference between them and I is the fact that I've provided myself with a platform, a means of developing my communication skills and thus, introducing people to what's been going on in my head for a long time.

When we were children there was no barrier or limitation in our communication process. What I mean by this is that when a child draws something or says something, it comes out without hesitation. We need to continue to nurture their creativity in order for them to continue advancing their abilities to communicate their ideas and feelings clearly and eloquently.

Contents

CONTENTS

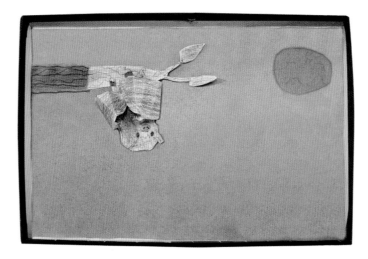

"Bat Collage" © Emilio Silva – Age 8

"In order for us to maintain our leadership position
in the world, it's not going to be dependent
on how well we teach math or science but
on how well we teach individualism and creativity"
– Albert Einstein

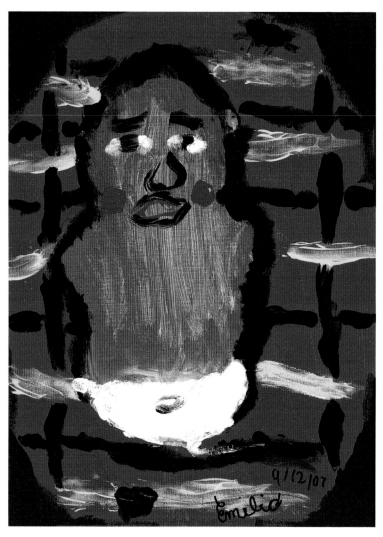

"Baby Boy" © Emilio Silva – Age 8

What Is Creativity?

Merriam-Webster says that creativity is: "The ability to produce something new through imaginative skill, whether a new solution to a problem, a new method or device, or a new artistic object or form. The term generally refers to a richness of ideas and originality of thinking." This is a great definition, but even this definition falls short of truly explaining what creativity is; creativity is something that you will recognize or experience once you see it, but it's truly even more than this as well.

Creativity is an ability to disregard all prior learning, as well as having the willingness to ask the right questions. Creativity is also a way to communicate feelings and

ideas with extreme clarity. In other words, being able to communicate with only the bare essentials (some would call this getting to the point as quick as possible). So let me provide you with some words that will shed some light on what I believe creativity is: spontaneous, dynamic, revealing, clarity, fearless, innocence, non-conforming, and precision.

What's the difference between creativity and talent?

Many people assume that most artists are creative but that's not necessarily true. I would say that most artists are talented but not necessarily creative.

I was working with Freshman students at a local college near Los Angeles and was invited by the director of a federally funded program to share my life story with students and to somehow nurture their creativity. Throughout the six-hour workshop I had a mixed level of enthusiasm and participation from the students. In particular, there was a young lady that refused to participate or try any of the projects. She wouldn't share thoughts or opinions on the various topics I brought up. I eventually gave up on this young lady when I saw her brushing on mascara during one of the most important parts of my lecture. However, as I was sharing a story about a cook in San Diego and his tip jar, I noticed that all of sudden

I had her attention. I was asking the students what amount of money would entice a guest to add money to the tip jar; half full, one third full, or completely full? The point of the story was to see if the students recognized creative ways to entice people to give. Some responded by saying empty, some said half full, and then it happened. The young lady raised her hand and she wanted to share her opinion with the rest of us. She politely said, "Mr. Silva, what's the big deal about this, who cares?" I responded by saying "This might help you someday with your tips for school!" She looked at me and said, "The answer to this is quite simple. Just paint the jar opaque so no one can see what's inside." She, in fact, had been listening all along and understood what I was trying to teach them. She was able to be incredibly creative while brushing on a few coats of fresh mascara.

Next time you're around children take the time to observe their amazing abilities and take notes. You might learn a thing or two about the amazing sensibility/ability that you once had. We've always had something to say, questions to ask, and things to explore but most of this has stopped.

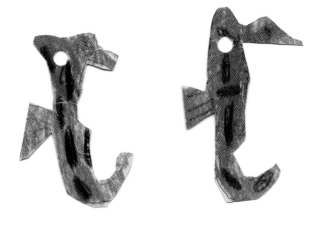

"Sea horses" © Emilio Silva – Age 6

*"Every child is an artist, the problem is staying
an artist when you grow up"*
– Pablo Picasso

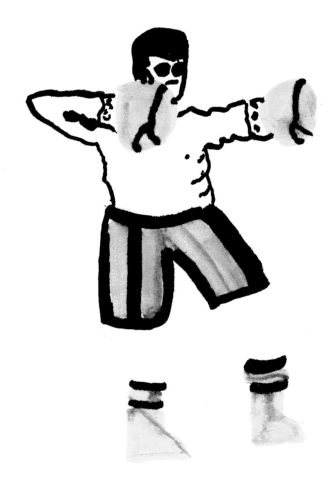

"The Boxer" © Emilio Silva – Age 6

"The Boxer"

Throughout the book I will be closely examining and describing incredible examples of creativity that were done by my kids.

Let's start with the example of "The Boxer" drawn by my son Emilio, at the creative age of seven. This is a great example that shows amazing creativity. He didn't start by drawing the boxer with a pencil first, he dove right in and used a black Sharpie and a yellow marker. This child was fearless!

I want to direct your attention to the pose of the boxer; it's a classic pose that has boxing written all over it. Notice the lines he used on the arms, they seem to indicate an

accordion effect to the boxer's punch. This definitely adds to the feel of a fight.

There's enough on the face to indicate a well groomed person that gives this piece an almost Hollywood movie feel, but still feels like the boxer belongs in the ring.

Notice the overlapping lines on the right side of the figure that indicate the abdominal muscles and rib cage. He does this only on one side as if to intentionally keep the drawing in it's purist form of simplicity.

The shorts are an amazing combination of perspectives. The left side of the shorts are facing the viewer and the right side of the shorts face away from the viewer. How do we know this? Because the left side of the shorts has the beautiful and intentional black stripe running down the middle of it. This is just enough to make it visually interesting.

Then, we arrive at the genius part of this piece. Notice the absence of the legs. Even though they don't exist in the drawing, we as the viewer are still drawn into the image in an enticing way that we fill in the legs with our imagination. So many pieces are left out in this art piece. These left out pieces engage the viewer in an unspoken conversation which makes the art piece more personal.

Lastly, we have the great looking yellow boots that

he accents with the thick and thin black lines that provide just enough curvature to make the shoes believable in our minds.

We, as the viewer, encounter an unexpected fresh and incredibly creative interpretation of a boxer. A drawing that holds our attention and engages us in a whimsical way.

Sadly, Emilio who is now 14, would have a difficult time creating something as unique as this today. He just wouldn't be able to replicate this again, which means his abilities now reside in his talent and not solely on his creative abilities. I believe this has come about because he's begun to care more about what others think and say about his artwork.

I've made it a point to redirect his attention back to his creativity that existed in abundance when he was younger.

"Creativity is allowing yourself to make mistakes.
Art is knowing which ones to keep.
- Scott Adams

What Is Art?

Growing up, I was under the impression that art was about being able to copy something and making it look realistic. This concept was reinforced by all of the teachers that I had in school. My teachers definitely instilled the idea that I was a great artist doing great art because I could copy something and make it look realistic. In the classroom, the artwork that received the greatest amount of praise was given to the most realistic drawings or paintings.

I now believe that art is more complex and more dynamic than a realistic image or something abstract. It can be both, but at the same time it can also be something fun, political, inspirational, cultural, historical, or disturbing.

Through the years, I've compiled a list of things that I believe will give you a better idea of what art is:

Art is a way of life: I have to be careful of what I expose myself to because I won't be able to sleep at night. Something exciting can get my creativity going and I need to respond immediately.

Art is an experience / a journey: Most people think that the final art piece is what art is. I say that it's really to be found in the process of creating the piece of art.

Art is a unique universal language: It's been very interesting to experience and read the many e-mails that I've received over the years from people all over the world commenting on my art. I believe that art is a universal language and I'm hoping one day (artists) are given credit for knowing the language of art.

Art is about communication: Art can express an idea, thought, or emotion when it can't be expressed with words.

Art is something that can take us to a place that has no boundaries: Art is the only thing that we have as a society that can take us to a place without limitations: when we sit down to listen to a great song (opera), read a great novel, experience a painting, or watch a great movie. It's an experience that can make us feel complete, as though we

understand human nature and ourselves a little better.

Art is about problem solving: When we look at the process of creating (being creative), we see that it's all about problem solving. We are inspired by something and we visualize this art (dance, song, painting, sculpture) in our head. This becomes the problem that we have to solve. How do we transfer this great idea into something tangible that others can experience? How do we create something that gives our audience the same experience that we're experiencing? This is basic problem solving.

Art is about inspiration: I came to the conclusion that my job as an artist isn't to confuse people; my job as an artist is to inspire my viewer, to provide clarification and/or insight.

Art is about answering questions: When we take a look at a powerful piece of artwork, we should be given an opportunity to answer personal or universal questions, and the answers should be there for the audience to embrace.

Art is what can make us more human: Through the arts we are given a wonderful opportunity to know the truth about life, ourselves (both good and bad), who we are, and who we need to become.

Art is about giving voice to the ignored: The arts is

the only thing we have that can show/portray the importance of everyone on this planet. Through a novel, song, movie, play, or dance anyone can be immortalized and given an opportunity to be seen as more than just a body or a number. An individual can be seen as a contributor to this planet within their existence.

Art is about respect: We, as humans with amazing brains, have the ability to recognize a half-hearted effort in someone's work. When we do our best with our craft we expect the viewer or the audience to provide us with all the respect that we deserve for our time and our talent.

Art is about creativity: When my kids were small I was amazed at their creative abilities and while in my studio I was more interested in observing their creativity than working on my talent as a painter.

Art is self-expression: Mr. William Winter said it best, "Self Expression is the dominant necessity of human nature."

Art is about making good decisions: When an individual sits in front of a piece of paper or a canvas, many decisions have to be made: composition, lighting, texture, line, color, and space. Great decisions are made in bringing a great piece of art to life.

Art is about explaining the unexplainable: Sometimes

an art piece can say more than words. It's almost as if a great piece of art is a condensed story.

Art is a way to develop our sense of purpose and a sense of direction: I have found that art can and will give an individual a great sense of purpose and direction, when the artist digs deep and continues to learn and explore!

"Boy 1" © Emilio Silva – Age 7

When We Were Kids

I was doing a workshop in South Los Angeles when I encountered a mother in the audience that shared a fantastic story about her son's creativity.

She said that her husband had a habit of buying their kids expensive toys that seemed to break within minutes of playing with them. On one occasion, her husband bought their youngest son expensive toy soldiers and moments later she saw her son playing with one of the soldiers that was missing a leg. Her instinct was to scold her son but she decided to try a different approach and ask him why he had removed the soldier's leg. To her amazement, her son told her a fantastic story about the soldier's mission. He

said that the soldier had found himself under enemy fire. During one of the bigger battles the enemy had hurled a grenade into the soldier's fort and there had been a great explosion causing the soldier's leg to fall off. After listening to her son's story, she remembered her days as a young girl using her creativity in her own games and stories. From that day forward, she never complained about broken toys but reminded herself to ask her children about their fantastic creative world.

It's important for all of us to take a look at who we were as kids. There was an abundance of creative activities that we did as kids; things that nurtured our creativity. These activities were simple, spontaneous, and more importantly, they were just plain fun.

The reason why it's so important for us to take a look at our past is that it gives us an insight of how much we've changed since we've grown up, but more importantly how much we left behind.

Here is a list of things that I came up with that I'm sure will sound quite familiar to you:

1. **Singing**
2. **Dancing**
3. **Playing**

4. **Drawing**
5. **Painting**
6. **Day dreaming**
7. **Pretending**
8. **Asking questions**
9. **Exploring**
10. **Imagining**
11. **Building things**

I'm sure this list might be longer for some than others but it should give you a view of what your world was like when you were a kid. I would like for you to add something to this list that you believe I left out.

Now, make your own list of specific things that you would do within each area. For example, if you liked singing, what kind of songs did you sing and why? What kind of games did you play? What kind of things did you draw?

As children we were pseudo professionals. What I mean by this is that as children, when we were drawing on the walls of our homes, we knew for a fact that our drawings were going to make that wall so much better. We were pseudo professionals. The reason I say this is because if we look at the definition of what a professional is, it will say something to the effect that a professional is someone whom has full

confidence in his or her abilities. When was the last time you sang? When was the last time you danced? When was the last time you explored?

I believe that the wonderful creative child is still within us but we need to wake it up and encourage it to play again!

*"The essential part of creativity is
not being afraid to fail"*
- Edwin H. Land

The Fear Of Starting

Fear is what limits us creatively: knowing where to start, what to draw, how to draw, and what to say. This is why I have such respect for kids and their fearless approach to their creativity.

Whenever I feel that ugly face of fear creeping in my brain, I always make it a point of making sure I ask myself what I would have done when I was a child.

We have to remember that sometimes we did things without rhyme or reason. We did things because it was fun!

Postponement of starting something is evidence of fear. Try the following project to help you overcome your fear and open up your creativity.

I want you to start by taking a small piece of paper and writing down your fears or better yet, things you're afraid of or are worrying about right now. Make a list of at least six things. Next, I want you to tear up that list into as many pieces as possible.

Next, grab a piece of paper; the bigger the better (butcher paper is great for this). Take color markers or crayons and write your signature as big as possible on that piece of paper. Grab another color and do it again; do this over and over again as many times as possible. Overlap them, vary the sizes and the angles of the signature. Try to put your whole arm into this. You should end up with something that looks like the sample on the next page; a masterpiece!

Doing something fun and easy will loosen you up creatively and build up your creative confidence!

"Signature Art" © Simón Silva

*"Creativity is inventing, experimenting,
growing, taking risks, breaking rules,
making mistakes, and having fun."*
- Mary Lou Cook

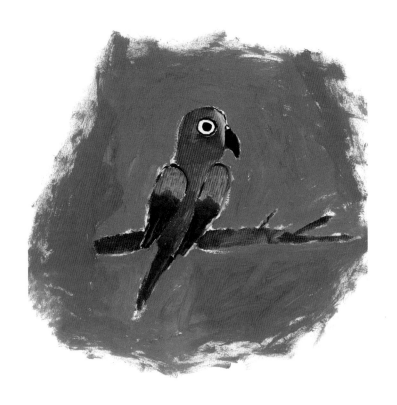

"Parrot" © Emilio Silva – Age 11

The Truth About Our Brains

One of the first questions I ask in my workshops is, "How many of you would feel comfortable writing a short creative story?" The hands that go up typically represent about 10% of the attendees.

The follow up question is addressed to the ones that didn't raise their hands, "How about the rest of you? Why aren't the rest of you as confident to do this?" and the answers are usually, "I'm afraid of what others might think about what I come up with," "I'm afraid that it might not be good enough" or "I'm afraid that I wouldn't know what to write about."

It's quite obvious to me that somewhere along the line

one of two things has happened: they have never practiced writing or they had some negative experiences throughout the years and now doubt their creative abilities. Does this sound familiar?

So let me give you the truth about your amazingly creative and beautiful mind. At night, while we sleep we dream three to six dreams according to recent research. Why is this so significant? It's significant and important to point this out in order to prove to you, without a shadow of a doubt, how creative your mind still is.

Our dreams at night are beautiful movies that we control and create while we sleep. We control every aspect of these dreams; the dialogue, weather, sights, sounds, the story, and we do all this while we are ASLEEP!

So, why aren't we able to do this while we're awake? I believe we've made up our minds that we're not good enough and that we don't want to expose ourselves to others who might be critical of our abilities.

Now that I have proven to you that your creativity is still very much alive and doing well, we can begin to work on getting you to believe in your creative abilities while you're awake. Start by asking yourself a series of questions to get your blood pumping and loosen up your mind.

What has been the strangest dream you've ever had?

What's the best food you've ever tasted?

What's the craziest idea that you've ever come up with?

What's your earliest childhood memory?

Write something true and something false about yourself. Share this with someone and see if they get it right. For example: I broke four bones in my body or I met President Obama? One of these is true and the other is false. Make them both so believable that even your best friend wouldn't know the answer.

By the way, I broke four bones in my body. It's a long story.

"Fall" © Emilio Silva – Age 10

Non-Threatening Materials

One of the most important things you can do in order to maintain an open portal to your creative mind is to work with materials that are non-threatening. In the past when I've conducted art workshops, the minute I would take out the brushes and pencils, participants were overrun with fear and began to complain and eventually shut down creatively.

What I mean by non-threatening materials is, using things you might have used as a child, such as crayons, Play-Doh, color pencils, paper, and boxes.

These materials will begin to bring you back to some fearless, curious, and exciting times when creativity was as common as the lint in your bellybutton.

One of the materials that I use in all of my workshops is Play-doh. It has great color, great texture and a fantastic unique smell. How can you be afraid of this? You can't!

It's important for us to recognize that words have the power to shut down our creative brains, but just as harmful are the materials that we work with. If you start trying to use materials that you're unfamiliar with it's quite possible that you're going to shut down your creativity and substitute it with fear and anxiety.

What sort of materials did you use as a child?

Make a list of things/materials that bring you fear and doubt; is it a brush, a pencil, a blank piece of paper?

Make a list of things that bring excitement and curiosity to your mind?

"Creativity is contagious, pass it on"
– Albert Einstein

Color Breathing Exercise

Many of you may find the projects in this book a bit overwhelming and challenging, so I want to provide you with a great way to help you relax before attempting any of the projects.

I started practicing this breathing exercise a couple of years ago in an attempt to help me relax during those overwhelming moments of deadlines, parenthood, or simply before speaking to a large audience.

I know that for those of you who have never practiced any kind of breathing exercises before, this might be a bit weird and funny. Don't worry, I felt the same way.

I want you to take a deep breath through your nose and

then exhale through your mouth, just like when the doctor is checking your lungs for any abnormal sounds.

However, because this is a book written by a creative person, I have to put my own twist on something old by adding a color to the air you'll be breathing. I want you to think of your favorite color and apply that color to the air. For example, if it's green, then you will be seeing a wonderful green air filling your lungs. If your favorite color is orange, then add orange to your air.

Close your eyes and take a long deep breath through your nose, hold it for about three seconds, and slowly exhale through your mouth.

Ready? Go.

Do this again, but this time really focus on the air filling up your lungs all the way up to the top, just like a color liquid would..

Ready? Go.

Do this at least three times and it will make a difference in getting you to relax. Do this before trying any of the projects in this book or whenever you feel overwhelmed or challenged. If you want to take this exercise to the next level then add a scent or a flavor to the air.

The Creative Elephant

A word of warning: you can become what you e-mail just like you can become what you eat!

Over the years my experience has been that owning a business and having a website generates lots of spam and e-mails, which at times can become a bit overwhelming.

I've learned some tricks on how to eliminate some of the spam, but when it comes to friends or family members I still have to do this the old fashioned way, one by one.

Over time, however, I've learned to classify those that e-mail me the chain letters, the get rich plans, and those that continuously send me fantastic, inspirational e-mails.

It was a few years back when a friend, with a track record of sending great e-mails, sent me a link to a video of an elephant that paints:
http://www.youtube.com/watch?v=He7Ge7Sogrk

While watching this video, I felt myself going from sheer excitement to being overwhelmed with disbelief. I kept asking myself, "How was this possible?"

I was expecting to see a funny, sloppy performance but instead, I was treated with an overwhelming sense of awe and wonderment!

I want you to ask yourself the following questions: Why can this elephant draw so well? Would I be willing and capable to compete with this elephant in a drawing contest? Why or why not?

Do you think the elephant can draw so well because it's not afraid of what other elephants think? Or maybe because the elephant has practiced, practiced, and practiced?

I knew this was something that I needed to forward to other creative friends and family, but more importantly, I wanted my students to experience this video and be challenged by it. So at my next workshop I played the video

and the response from my students was equally as powerful as mine had been.

However, when I asked the question, "How many of you are willing to challenge this elephant in a drawing contest?" To my surprise, only a handful raised their hands, while others were hiding with great shame.

I decided that this wonderful, creative elephant was going to be a catalyst for showing my students how to overcome their fear(s) of drawing and being creative.

Materials needed for this project: black pen, white paper, timer, two crayons (red and green or orange and blue).

Observe the video, keeping in mind that our brains work like a video camera; we can even pretend that we activate the camera with the twitching of our nose or the pulling of our earlobe. We can replay that video recording anytime we want. Remember this because we will be using this later in this exercise.

Set your timer to sixty seconds. Take a moment and practice your color breathing. Be honest about following directions and not letting yourself cheat. Place a white piece of paper and your favorite crayon or a black pen in front of

you. I want you to do your best and draw the best-looking elephant you can draw. Start your timer and draw. You only have 60 seconds to do this. Ready? Go!

Once you are done, please write down the date, your name, and the words, "sixty-second drawing."

Next, I want you to do something that will sound impossible to do but it's not. I'm going to ask you to draw the elephant with your eyes closed. After you stop complaining and doubting yourself, I want you to take a color breath so you can relax. Maybe two or three breaths just too make sure you're ready.

You're going to practice a form of drawing called "contour drawing." The traditional way of doing contour drawing is that you always keep your eyes focused on the object and never look at your paper while you are drawing. We're going to do something similar to this, however, we're going to make it a little more difficult by closing our eyes as soon as our pen or crayon touches the paper.

Place a mark on your paper where you think the elephant started her drawing. With your eyes closed, I want you to pretend to re-play the elephant video in your head while you

are drawing. Make sure you take your time, this isn't a race. Do only one part at a time. For example, the top of the trunk and then the top of the elephant. Make sure you take your time to see what you have drawn. Close your eyes again and tackle another part.

Don't worry, it will get easier.

Once you are done with your drawing, write down the date and "drawing with eyes closed" on your paper.

This time we will be drawing the same elephant but now we are going to focus on shapes. Think about what shape the trunk, legs, head, tail, and ears have. The reason this is so important is because fear comes from the unknown but we can put a stop to this fear when we use our wonderful brains and break things down to bite size pieces that we can identify and work with.

Now, take your crayons (red and green or blue and orange), a piece of paper, and start with a warm color (red or orange). We're going to start our drawing in the same place as the last time, but this time we're going to ask ourselves, "What shape does the trunk have?" I would say that the trunk has a shape similar to a fat snake; fat on one end and

skinny on the other end. So go ahead and draw this shape. Don't worry about how it looks.

Next, think of the shape of the elephant's body. What shape does it have? I believe it looks like a circle or an oval, so draw this and don't worry too much about how it looks. Don't think so much at this point, just draw that shape. Next, ask yourself, "What shape do the legs have and how many legs does an elephant have?" I think the legs look like cylinders and notice that two legs are going forward and two are going back. One of the front legs is forward and one of the back legs goes back and vise versa. Ask yourself, "How is the elephant able to bend it's legs?" It needs knees, right? Draw a shape on the leg that you think represents a knee.

Once you are done, take your cool color crayon (blue or green) and this time you are going to go over your drawing and connect all of the shapes. Somewhere on the drawing write, "drawing with shapes" and the date.

Take a moment and practice your color breathing. Set your timer again to sixty seconds. Pick up a black pen or a color crayon and a clean, white piece of paper. With your favorite color crayon or black pen draw the best-looking

elephant you can draw. Start your timer and draw. You only have 60 seconds to do this. Ready? Go!!!

What you should have learned from this way of drawing is that you can detour your fears by thinking about things logically. By breaking things down to shapes and logical thinking you can increase your confidence and your abilities.

On the following page is an example of my son's work.

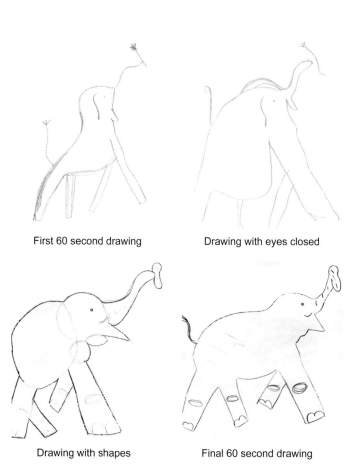

First 60 second drawing

Drawing with eyes closed

Drawing with shapes

Final 60 second drawing

"Elephants" © Emilio Silva – Age 10

"Creativity is experiencing something unexpected"
– Simón Silva

"Butterfly & Squirrel"

I was so inspired by the elephant drawing video that I decided to try something on my youngest son, Emilio, who is always up for a creative challenge. I was going to have him compete with the elephant in a head to head drawing or painting contest. I began by making a bet with him and telling him that I knew of an elephant that might be able to take him in a drawing contest. His answer was of course "No way!" So I showed him the video and watched him stare at the elephant's strokes in disbelief, observing carefully what the elephant was able to do. Once the video was done, he jumped to his feet and said, "I know I can beat this elephant but I don't have a trunk to paint with, so would it be okay if I

paint with my mouth?" He was going to attempt to draw/paint with a brush in his mouth, so I replied, "I think that would be a fair contest." He disappeared into my studio for a couple of hours and returned with a beautiful painting along with the brush he used. The brush was displaying fresh teeth marks and was dripping with saliva. The poor elephant didn't stand a chance and this was quite evident with the masterpiece Emilio had pulled off.

If painting this beautiful image with his mouth wasn't difficult enough, the simplicity of this piece and what he was able to do with simple brush strokes made it even more impressive. I want to direct your attention to the beautiful monarch butterfly in the middle of the image, but what is less obvious is the squirrel on the bottom left hand corner of this piece. Can you see the squirrel eating the nut? We have the blue brush stroke representing the clouds at the top and the brush stroke of green at the bottom representing the grass. The simplicity of being able to capture the essence of the squirrel in three or four strokes makes this piece creatively amazing.

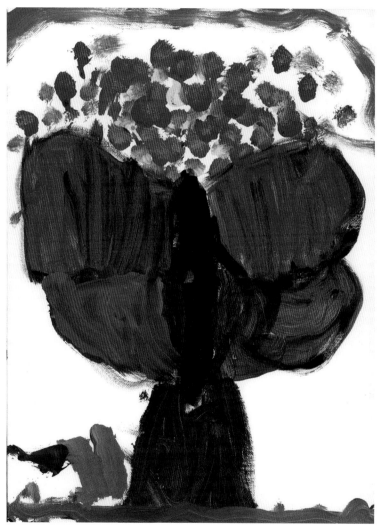

"Butterfly & Squirrel" © Emilio Silva – Age 10

"I Can't"

"I can't ," are two dangerous words that I hear more than I would like to hear, especially in the context of a creativity workshop. These two words, unfortunately, are the beginning of sentences like: "I can't draw," "I can't write," "I can't paint," and once in a while I hear something a bit different: "I'm not creative." Tragically, these words are being used by kids as young as second grade but often used just as much by: college students, parents, and business people.

My response to anyone that uses these words is "How often do you practice drawing, writing, painting?" Their answer, of course, is the same, "Hardly ever." It's a big revelation to individuals when I tell them that without

practicing, we won't be able to do much. The same could be said about being a creative person and developing our creativity. If we don't regain and nurture our curiosity, our creativity will remain dormant. The solution for this situation is that all of us need to practice, practice, practice, and practice.

If any of us were on a basketball team, I'm sure that without practice we would be sitting on the bench. The same thing goes for our creativity, if we don't practice we'll be sitting on the sidelines afraid to be put in the game because we'll be saying "I can't . . ."

So everything in this book has to be done and practiced on a regular basis.

"Creativity is just connecting things"
- Steve Jobs

Creating Better Professionals

Since I've been able to afford health care insurance, I've gone through about twenty-eight doctors and the sad part about this is that I've only been impressed by four of them. The majority of my doctors had poor communication skills, bad bedside manners, and limited medical skills. However, this isn't limited to doctors. I've found the same in professors, artists, engineers, teachers, and many other professions.

So the question is, how can this be?

I believe the problem centers in that many of us have been pressured into certain professions because of tradition, money, status, and respect. How many of us pursue what we're really good at?

I was introduced to a video called, "Caine's Arcade," (http://www.youtube.com/watch?v=faIFNkdq96U), a video of a boy that creates an arcade out of cardboard boxes in the front of his father's auto part store in East Los Angeles.

What struck me about this video, aside from the incredibly creative mind of this boy, was the fact that this video proved to me that Caine was going to do incredibly well in any profession because he was continuing to nurture his amazing creativity.

Why? Because at the end of the day, as professionals, all of our jobs require results. As professionals we strive to become better communicators and better problem solvers in order to have greater success.

We had amazing creativity as children and it's that creativity that will make us better professionals no matter what we end up doing in life!

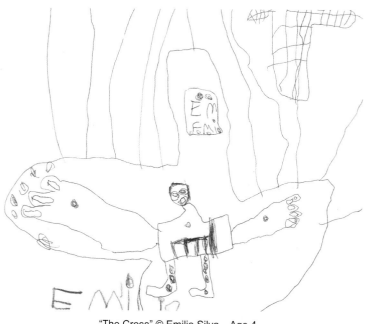

"The Cross" © Emilio Silva – Age 4

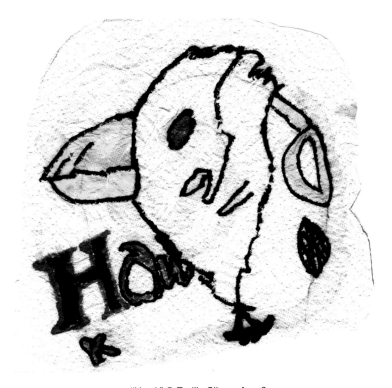

"Hawk" © Emilio Silva – Age 6

"Hawk"

My youngest son, Emilio, considered himself a big boy. He was entering first grade and it was important for him to arrive at school with the current fashionable accessories. His older brothers were currently fans of skateboarding, so Emilio decided that he would also become a big fan as well. This meant acquiring a new Tony Hawk backpack to prove it. His brothers already owned skating theme backpacks. So he decided that instead of the superheroes backpack that my wife had purchased for him, he wanted something with skateboarding logos.

Unfortunately for him, my wife was not about to buy him a new backpack, since she had already purchased a good

and sensible superhero backpack. So he decided to take matters into his own hands and began to customize his superhero backpack with an original Tony Hawk image. It was going to be bold and daring, just like him.

He grabbed a white sheet of extra absorbent paper towel, a black Sharpie, and some markers. He was determined to create the best-looking artwork ever. No sketch, no measurements, just a vision in his creative mind that spoke to him, directing his every stroke like a pre-recorded message. First the outline of the head, and just enough detail on the beak and the head to make it look like a bird. He used some yellow for the beak and an amazing choice of green for the eye. The lettering came next, a cross between Times bold and ancient hieroglyphics. Then a mistake occurred. Wow, not enough room to fit the entire word! "No problem," says his creativity, "just make the letters smaller and bring the last letter underneath, close enough to say that it was all planned."

A proud sigh and a run for the cabinet in search of a method to apply his creation to his backpack; tape, paper clips, and rubber bands. It didn't look very promising. Then he spotted the familiar cow on the good old reliable Elmer's glue. This will do the job. He flipped his drawing over and

smothered it with love and lots of white glue; making sure there was enough to keep it glued and safe until at least junior high. The superheroes were gone and now The Hawk was proudly displayed, ready to be shown off to the entire school with hopes of encounters of jealous faces and inquiring questions about his original design. The school day came and went and Emilio arrived from school without a smile on his face and without his masterpiece decorating his backpack. He had been a victim of unappreciated minds looking for familiar store bought backpacks with superheroes.

He eventually accepted defeat and with that came the destruction of the hawk image, crumpled up and left behind for a proud mother to recover and display proudly on her bedroom dresser. That evening Emilio worked furiously scraping the globs of glue from his back pack, making sure that on-lookers were still able to recognize at least one superhero.

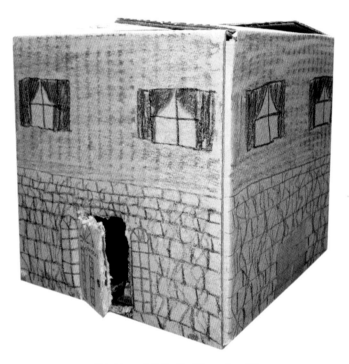

"My House" © Emilio Silva – Age 13

Cardboard Box Project

Growing up poor in the barrio, there was no money for toys or entertainment, so we made up our own games and made our own toys out of materials found around the house. A plastic butter container cover became a Frisbee, a cardboard box became a car, a boat, a spaceship. There were no limitations as far as we were concerned. I'm only mentioning the safe toys we invented. There were plenty of dangerous ones that had the potential of inflicting major injuries if not properly played.

To my parents back then, and to many parents (adults) today, a cardboard box is simply a piece of trash but to all of us as kids a cardboard box had infinite possibilities. We had

an amazing sensibility (creativity) that had no limitations, no doubt, and no fear!

I want you to find a small cardboard box, but if you want to make it a big box then you will get extra credit for your enthusiasm. Along with the box I want for you to find some scissors and a box of crayons.

First, think back to when you were a child and write down a list of things that you would have done with the box in front of you: a spaceship, a store, a car?

Pick one of those things and apply it to your box. Remember that you can do anything you want with this box; there are no rules, no grades, no limitations.

You can color it, bite it, stomp on it, cut it up, or you can tear it. Just have fun!

Enjoy and remember to display it proudly in your home or office. I guarantee it will strike up a conversation.

"Truly creative people care a little about what they have done, and a lot about what they are doing. Their driving focus is the life force that surges in them now."
- Alan Cohen

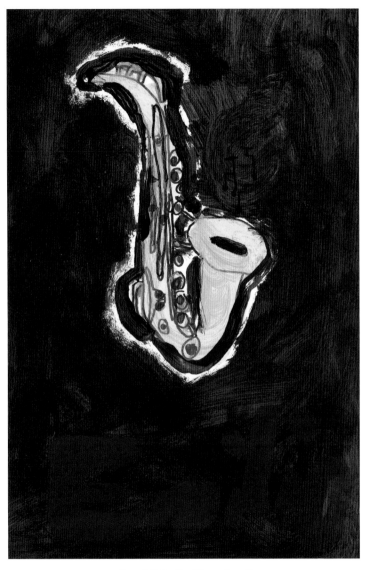

"Jazz" © Emilio Silva – Age 7

"Jazz"

One of the ways I've nurtured my own creativity has been through the use of variable experiences. What I mean by this is that I've made it a habit to seek out new things, movies, art, books, and of course my personal favorite music (Jazz).

My wife and I have always strived to mix things up around the house, hoping to provide our children with a variety of genres of art as well as deep and provocative conversations.

At the end of the book I've included my recommendations of books, music, and movies that have not only entertained me but have also nurtured my creativity.

Most people assume that as a painter my only source of inspiration comes from other painters, but that's not the case at all. There's been plenty of occasions in which a great movie or a great song has inspired a painting or a story.

Along with collecting vinyl, I have also collected a few old instruments that I proudly display in my studio; a tiny pocket trumpet, a normal size trumpet, and a beautiful saxophone purchased in a heavily fortified pawnshop on the north side of Denver.

Over the years, all three of my sons have painted along side of me in my studio. It was during these times that I did very little painting and watched attentively at their creative methods.

One of the things that captured my youngest son's attention was the beautiful saxophone that I proudly displayed on one of my shelves. There was something about that saxophone that must have spoken to him; the elegant long curves, the many keys, or its resemblance to an elephant's trunk. I watched as he studied the saxophone carefully from top to bottom trying to decide what angle he found to be most dynamic.

He began his project by pulling out his old reliable black Sharpie and carefully outlined the saxophone, with its long

neck, followed by the many keys, and ending with the bell at the end of the instrument. He knew, somehow, that notes came out of that open hole and decided to "capture" some of those notes which seemed to magically float away.

He then began to add the blue background using acrylic paints from one of the many sets that I had purchased for him over the years. It was a blue, dark enough to provide a rich contrast against the golden yellow, that he had added to the saxophone. It's incredibly interesting how he diluted the paint just enough to let the initial drawing done with the Sharpie come through. It was subtle, yet still somewhat prominent in the painting.

He then added the red dots to accent some of the keys, giving it a feeling of movement; fingers leaving a warm stain as they jumped from note to note.

He seems to leave the best for last as he makes a defiant, yet subtle move, signing his name across the entire bottom of the painting as if to say, "Yes, I did this."

CULTIVATE A CREATIVE MIND

"True creativity often starts where language ends."
- Arthur Koestler

82

Exploring Tools & Materials

Materials and tools can indeed nurture our creativity. For instance, in looking at children playing with their food I can see their creativity level explode when the materials in front of them offer them unexpected surprises.

I've witnessed children at a sushi restaurant take chop sticks to draw with water then turn right around and pretend they're playing a violin, it's fantastic!

Exploring what our tools and materials can do for us will inspire further exploration and creative application. We need to know what a pencil and a black pen can do for us. We also need to know what substitutions we can make when we run out of things to use when working on your projects.

I would like you to get a piece of paper or brown paper bag and a pencil. Hold the pencil in your hand and draw some lines on your paper or brown paper bag. Apply different amounts of pressure on your pencil and as you make the lines watch how less pressure results in thinner and lighter lines. You should also notice that as you apply more pressure on your pencil, your lines will become darker and thicker. Now, hold the pencil sideways in your hand and watch how you can make some beautiful shading with the side of the lead.

Next, take a black ball point pen and make some more marks on your paper. Make some lines that are close together, as close as you can make them, and slowly begin to make lines further and further apart. Make some curved lines, some straight lines, make some stippling on your paper by pecking on your paper with your pen. Observe the rich contrast that a black pen can make for you on the paper. Make some more lines, but this time cross those lines with another set of lines and see how many patterns you can make by crossing lines with new lines.

For this next project, find some colorful fruit or vegetables such as raspberries, strawberries, beets, or carrots. I want you to crush some of the fruit and vegetables and save the

colorful juice on a plastic lid. Take your finger and dip it into the colorful juice and make some marks with your finger on a piece of paper. You might want to use a thick paper so it doesn't get soggy and tear. Find out what other colors you can make with other things like grass or seeds.

Next, go to your refrigerator or pantry and find a jar of ketchup and some mustard. Squeeze the mustard and the ketchup and make one of those early paintings you did as a child. Take a look around and see what other things you can use to paint an image; try some KoolAid with a tiny bit of water.

Awesome, you're playing with your food!

"My House" - Ketchup & Mustard © Emilio Silva – Age 14

"Creativity is improvisation"
– Simón Silva

Words

It should be no surprise that language (words) is constantly changing, evolving into new meanings. Drugs are now "recreational drugs", gambling is now "gaming", retirement homes are now "luxury adult living communities" and one that I came up with is the word "transition"; the new word for retirement.

Our minds respond to words and that response varies depending on how we process certain words. For example, in many of the workshops that I've done over the years if I announce to students that we're going to draw or write, this is usually followed by loud opposition. This is fear appearing as sound!

This is why I no longer call myself an artist. I call myself a Creative Problem Solver or CPS for short. This new title has a tendency to fair far better in my introductions to people then saying I'm an artist. The word "artist" has become outdated and it is no longer able to represent the importance of the arts. Instead, in many cases it creates confusion and misconceptions. Artists and the arts are often viewed as unimportant, bizarre, strange, snobby, and a waste of time.

We need to update this word in order to bring about the respect the Arts deserve. I believe that once we do this,we will be able to get back on track, encouraging all of our children to continue nurturing their creativity and curiosity.

More importantly, we need to make everyone believe that the arts are essential in everyone's life. The Arts should never be something cut from our school's curriculum, ever!

Write down the words "I CAN" on a piece of paper and tape them on the wall of your creative space and declare war on your doubt!

Up & Down Logo © Simón Silva

"Mom"

My son Josué and I were painting in my studio one day and I saw him having a difficult time with his painting. I found it to be quite odd since this was the first time I had seen him frustrated artistically. I went over to him and asked him what was wrong and he explained to me that he wasn't able to mix the right skin tone for the figure that he was painting.

I suddenly realized that as he was getting older he was being influenced by what I was doing. He wanted to paint just like me and this wasn't a good thing. He was already much better than I was at his age. Not wanting to influence his creativity, I looked into my library of art books and found the fantastic art of my favorite artist, Vincent Van Gogh. I

frantically searched the images for the beautiful but odd painting that he did of his mother called, "Portrait Of Artist's Mother, 1888," located at the Norton Simon Museum of Art in Pasadena, California.

I was looking for this specific piece because I wanted to show him a fantastic example of using a green palette. A fantastic use of something fresh and wonderfully different.

As my son stared at this piece, he studied it carefully and realized that he could use any color for his skin tones. He had already been doing this quite well, as can be seen in the portrait of my wife created at the age of seven years old.

In this portrait he gives his mom green hair, luscious red lips, a yellow face, a purple night gown, and some stylish slippers, just like Van Gogh would have done. It was a loving representation of his beautiful mother.

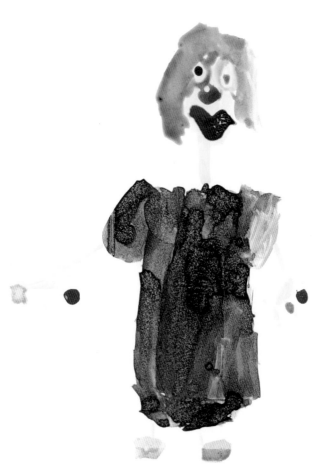

"Mom" © Josué Silva – Age 7

What Do You Want To Say?

When I ask students to draw something, anything, one of the things that prevents individuals from being successful is the fact that they want to draw something that looks realistic. This is something that happens not only with adults but with many children as well.

In other words, they start off with the wrong mind-set. If they would start by focusing on what they want to say, it would provide them with direction and inspiration.

Let me give you an example, if I were to ask you to draw a rat, you would probably want to draw something that looks realistic. I would like for you to try something different. Think about what you would like to say about this rat; is it a fat rat,

is it skinny, is it hairy?

As children this was something that we did automatically. We knew exactly what kind of rat we wanted to draw because our creativity had already dictated what kind of rat we were interested in drawing.

This is why it's always important before we begin the process of creativity to find what it is that you want to say. I see individuals wanting to be creative, but they have no context or direction as to what they want to say.

Listen to a few songs and pay close attention to the first few notes and see if you can recognize the type of song it is by those few notes. What are they trying to say to you? Is it a happy song, a love song, a sad song, a melancholy song? In other words, what is being expressed?

Before you pay too much attention to the drawing aspects of a painting, take a moment and see if you can recognize the message that is being portrayed by the use of color, lighting, size, and texture.

Knowing what we want to say can make it easier to be creative, especially if we find something that we're passionate and excited about.

So remember to always start with asking yourself: What is it that I want to say?

"If you hear a voice within you say,
"You cannot paint," then by all means paint,
and the voice will be silenced."
- Vincent Van Gogh

Hummingbird Project

We currently have three hummingbird feeders hanging outside of our kitchen window. It's during the summertime that we have an explosion of hummingbirds that invade our backyard in an attempt to drink what we offer.

I never get tired of watching these beautiful birds zooming past us like jet fighters on a mission to evade the competition, which seems to grow in numbers every year. Not only am I impressed by their agile movement, but their colors and their impressive beak.

For this project, go out and seek a hummingbird and study it. Look at it's movements, it's beak, colors, and body. If a hummingbird isn't available for study purposes on your

premises then a good Youtube video will do. Please watch the video carefully, watch it over a few times to familiarize yourself with the shape of the bird and its speed. Don't get stuck on the small details, focus on the overall impression of this magnificent animal.

Once you watch the video I want you to write down a list of things that impress you about these birds; is it their size, agility, color, or their beak? I don't want you to have any reference in front of you to draw from. I want you to focus on what you remember.

Then take a black ball point pen and tell me what it is that you want to say about this bird. Think about the features that make this bird recognizable as a hummingbird. I would say that for me it would have to be the beak, the tiny body, and their amazing wings.

Draw the beak and make it quite large. Do you want to make the beak straight or slightly curved? What about the body? Do you want to make the beak as long as the body or smaller? How would you draw wings and show them flapping at a blazing speed? Don't commit to a particular line. What we're trying to do here is to get the feel of what it is that you want to say. Take a look at the quick sketches that I've done on the next page. Have fun!

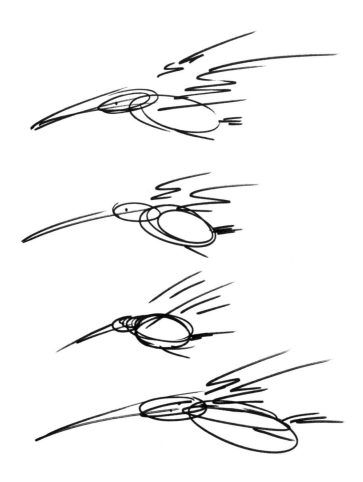

Hummingbird Sketches © Simón Silva

"As competition intensifies, the need for creative thinking increases. It is no longer enough to do the same thing better . . . no longer enough to be efficient and solve problems."
- Edward de Bono

8.5" x 11" World

I know that I've suggested that you use an 8.5" x 11" white piece of paper for some of the projects in this book but I want to make sure you recognize how much the materials that you use will affect your creativity.

The worst thing we can use, especially when we're trying to awaken our creativity, is a standard, boring white piece of 8.5" x 11" paper. I point this out because I want you to be aware that something as simple as changing the shape or size of paper can get us out of our creative paradigm.

The reason I'm saying this is because we do most of our work on 8.5" x 11" pieces of paper: our work, our charts, our homework, and many times our artwork. We are trapped in

an 8.5" x 11" world and we don't even realize it. I want to urge you to mix up the surfaces and the paper that you use to be creative. Instead, use things like 3" x 3" sticky notes, butcher paper, or a brown paper bag.

Here's an exercise you can try: Start with a 8.5" x 11" piece of paper and tear the paper starting at the top. Be careful and intentional in your cuts paying close attention to make sure you end up with long tears, short tears, round tears and square tears. Try this a couple of times using different size papers. Study your paper and recognize the beautiful creation that you've made. What size is it now?

(See sample on next page)

Next, I want you to take your papers, crumple them and un-crumple them. Take a look at all the wonderful creases on the surface. Be conscious of the materials you use and of the surfaces you draw or doodle on. **Mix it up!**

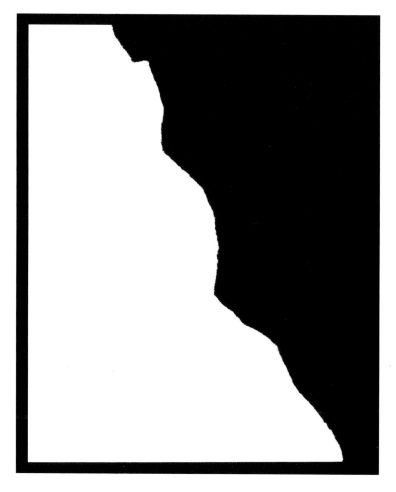

Cut Paper © Simón Silva

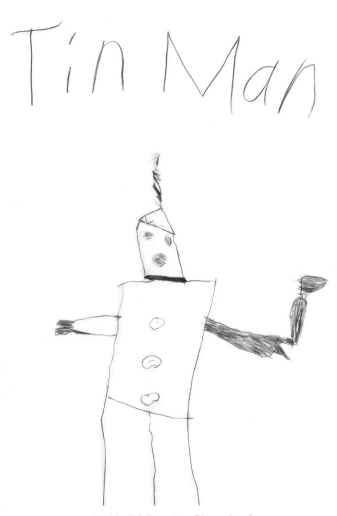

"Tin Man" © Francisco Silva – Age 6

"Tin Man"

At age 6, my son Francisco, had just watched the movie *The Wizard of Oz* and was immediately inspired to create his version of the Tin Man. This drawing brought a smile to my face the first time I looked at it. I became engaged in the simple, yet rich rendition of this character. I liked the simple mechanical feel to the body, as well as the subtle body gesture leaning over to the right, just enough to wonder what's going on with the right arm. The arm resembles a prosthetic arm, not quite fitting in with the rest and is offset by the tiny left arm. There's just enough detail in the face and torso to allow the imagination to fill in what's missing. The finishing touch is the fine wispy smoke rising out from

the top of the head. Francisco was in the process of learning how to write and he took this opportunity to label his creation in case anyone had difficulty identifying who this was.

Slow Down & Focus

As a creative person I have found that the only way for me to be as creative as I can possibly be, is to slow down and not try to multi-task. I have yet to find someone that is able to be super creative and carry a conversation at the same time.

I find that most people have a tendency to carry bad habits into their learning. One of them is having the tendency to want to talk while they work on a project. This is something that inhibits most people from being as creative as they could be. The individual automatically overrides any existing details by guessing at what is there instead of carefully studying what's in front of them.

An easy way that everyone can become more creative is to learn how to be observant, quiet, and to focus before they start any project. This will make you a better problem solver and much more creative. You will accomplish this by not missing any of the good stuff that's right in front of you, or around you.

I experienced this while my car was being serviced and I walked to a nearby store. On my walk, I began noticing new things in my neighborhood that I had never noticed before: houses, bushes, trees, dogs. It almost seemed like an entirely different neighborhood. Those things were always there and I would have noticed them if I had slowed down and taken the time to observe them.

Vegetable/Fruit Project

The following project will help you understand and practice your observation skills.

Start by picking a fruit or a vegetable. I would recommend an onion, but you can pick anything you want or find in your kitchen. Place the fruit or vegetable on a solid color surface and hold the fruit in front of you. Turn the fruit around in your hand and examine the surface. Carefully study the color, texture, and the shape. Describe what you see; write it down on a piece of paper. Draw the fruit with a black pen; don't worry about mistakes. Remember to breath and slow down.

Next, cut the vegetable in half and study the inside, the shape, color, and texture. Take down some notes on what

you're observing. Ask yourself if you've discovered anything interesting or new about the vegetable. Does it look different to you now?

Take one of the halves and cut it in any direction you would like and again study the new shape. Ask yourself if it reminds you of anything. What do you see? Continue cutting the fruit and see if there's any changes in the shapes or the color.

This project will help you to visualize things from different perspectives. It will give you a different point of view and help you see things in greater detail.

(See sample on the next page)

VEGETABLE/FRUIT PROJECT

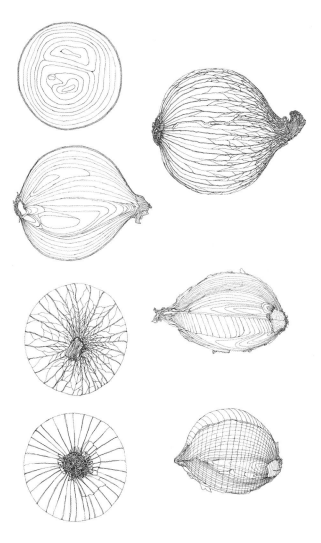

"Onions" © Simón Silva

111

"Hawaiian Girl" © Emilió Silva, Age 7

Principles Of Design

Have you been to a museum or a gallery and asked yourself: "What is this?" or "How do I even begin to understand this?" I would first recommend that you find an artist quote about the show or maybe the curator so those questions can be answered; don't be embarrassed.

The other thing you can do is to memorize the principles of design. This list will help in critiquing any artwork or art forms. Yes, even abstract art requires the application of some of these principles to create a refined piece of artwork.

If this is the first time you've ever encountered this list, don't be afraid. I'm going to define and explain each one of them just like I did with the art projects. Before I do this,

though, let me point out that if you look at the principles of design you will see something quite obvious. They are all direct opposites but with a balance within each one of these rules.

We, as artists, have known that we don't have to reinvent the wheel; mother nature has already created perfection. If we look at a flower, not only will we see it's beauty, but we'll also notice that all of these rules exist in it and all that is in nature.

- **Light vs. Dark** – Mother Nature has given us day and night, which is the same as Light vs. Dark. How do we look for a good balance of Light vs. Dark in art? Start by squinting your eyes, the light areas should recede and the dark areas should come forward. We need good contrast of light versus dark for art to pop!

- **Long vs. Short** – There should be lines or shapes that are long and some that are short.

- **Pattern vs. No-Pattern** – Certain areas will have a pattern (dots, lines, etc.) and there should be areas that are solid color.

- **Straight vs. Curved** – Some of the shapes or lines should be straight and some should be curved.

- **Color vs. No-Color** – This is talking about the fact that

we would have areas of black (absence of color) vs. areas of color (red, green, blue, etc.) elsewhere.

• **Soft vs. Hard** – There should be some shading (soft edges), and some hard lines (hard edges).

• **Cool vs. Warm** – If you were painting an ocean scene you would probably use cool colors like blue and green. However, if you were painting a volcano you would use warm colors like red, orange, and yellow.

• **Large vs. Small** – There should be some shapes that are large and some shapes that are small.

• **Wide vs. Narrow** – There should be some shapes that are wide and some shapes that are narrow.

Keeping these rules in mind should provide you with a greater understanding of how to approach a drawing, a painting, or even an abstract art piece. Now that you're aware of these rules, there should be less fear in doodling, drawing, or attempting a painting.

"Safari Animals" © Emilió Silva, Age 6

Nature/Design Project

The Nature/Design Project will help you understand and apply the Principles of Design. Materials needed: black pen, color pencils, white paper, photo of a fish, animal or flower. If you prefer, you can also work from the actual objects.

Start by drawing a T-shirt or skateboard template with the black pen. Don't worry if it's not perfect (see template below).

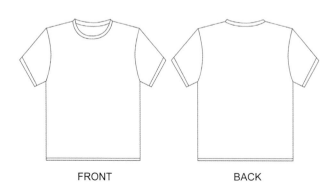

FRONT BACK

Take a moment to breath if this is already scaring you.

Observe the item you're going to draw and study its color, texture, lines, and shapes. While you're doing this, make some notes (mental notes if you prefer) and decide what direction your design will be in: horizontally, vertically, or diagonally. Once you decide this, begin applying your design to either your T-shirt or your skateboard.

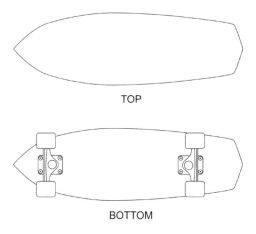

TOP

BOTTOM

Be very careful when guessing at pattern lines and dots. Many people make the mistake of guessing when they create a pattern, lines, dots, etc. We need to understand that we have amazing brains that can figure out things quite easily when it comes to patterns. The samples on the next page are what most people create. The one on the right is one that is created by someone actually taking the time to create a complex pattern that is harder to figure out. Thus,

there's a greater appreciation for the pattern that is more complex and defined. Again, take your time, don't rush, be clear in what you are observing and try not to guess.

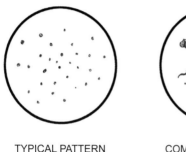

TYPICAL PATTERN COMPLEX PATTERN

Once you have your design on your T-shirt or your skateboard, you can begin applying color to your design. You will be using colored pencils for this part of the project. It is important that you know colored pencils are colored wax, so when you apply the color to the paper, you are sealing the paper with wax. It's best to start by applying the lighter colors first: yellow, orange, red, and then apply the darker colors like blue, green, brown, and black. Try not to burnish down the colors too hard, especially when you begin. The reason for this is because it makes blending the colors difficult.

Keep the list of design principles in front of you so that you can remind yourself of what you need to include in your design. Have fun! (See sample on the next page)

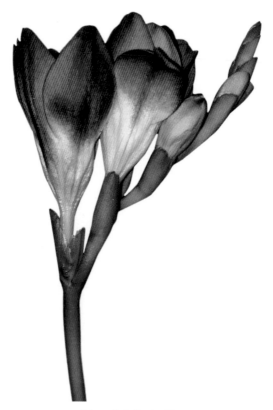

"Flower" © Simón Silva

FRONT

BACK

T-shirt Design © Emilió Silva, Age 14

"The Bear" © Emilió Silva, Age 9

Interview With A Monster

Anytime I watch a great movie I always make it a point to watch it all over again with the director's commentary; it always feels as though I'm taking a private film class. The insights shared by the director and actors reveal the tremendous amount of the creative thinking that took place during production. It was after one of these movie experiences that I came across a wonderful creative insight. The movie "Interview With The Vampire: The Vampire Chronicles," a delicious, well done movie that lead me to re-watch it with the director's commentary. This time, though, it also included an interview with the novel's author by the name of Anne Rice. Anne Rice revealed the simplicity

of her creative idea for the novel. She was interested in vampires and wondered what it would be like to interview one. Sometimes creativity comes with something that we love to do or wondered about, like interviewing your favorite monster.

So we're going to try this. Pick your favorite monster, celebrity, or thing and pretend that you're actually interviewing them. Make an effort to consider how they would answer your questions: would they be serious, would they be funny, would they be shy? Let's see what you can come up with.

Here is a sample that I happened to work on; an interview with Frankenstein's Monster, enjoy!

Simon: Do you see yourself as a monster?

Monster: No, not really, I think people see what they've read about me or what they've been told.

Simon: So you don't scare yourself when you look in the mirror?

Monster: Scare myself? I don't see myself as being scary. It's not like I have a choice. I didn't have a baby face or a teenage face. This is all I've ever known.

Simon: What's the deal with the bolts on your neck? What does it feel like to have those sticking out like that?

Monster: Well, sleeping is a bit tricky I can only sleep face

up or face down. They feel like someone stabbed me on the neck.

Simon: Have you ever thought about being someone else?

Monster: Dracula would be great. He gets the girls and is able to fly away if danger is near. It's hard for me to run, I'm a bit uncoordinated.

Simon: Do you have any pain?

Monster: Physically I feel fine. Dr. Frankenstein did a great job putting me together. I get a bit of a headache once in awhile, nothing an electric shock can't take care of.

Simon: It appears from your movies that your eyes seem a bit watery. Can you see very well?

Monster: I can see just fine. I would say that I have 20/20 vision. However, the light seems to bother me a bit, especially high powered flashlights.

Simon: Do you really dig the girl that was made for you by Dr. Frankenstein?

Monster: Do you mean The Bride of Frankenstein? You know what really bothers me about this whole monster thing? It's the fact that I don't even have a name and neither did my bride. I had an arranged marriage and from what I hear these things don't last very long and it didn't.

Simon: So what do you do for fun?

Monster: I do shadow monsters. I do a bit of sewing, especially on my one outfit that I have. It gets a bit tattered after a good day of scaring.

Simon: When you fought the werewolf, was it staged like the wrestling matches?

Monster: Come on, I'm not going to disclose show business secrets. What do you think? All I can say is that Wolfie lives down the mountain from me.

Simon: Would you like to have kids someday?

Monster: No, I would not. This is a cruel world for individuals that look different and I wouldn't want them to go through the ordeals that I've been through. Besides, it's not like I have a job to support any children.

Play-Doh Baby Project

One of the materials that immediately came to mind when I was looking for materials to nurture my student's creativity was Play-Doh. Think about it, who's afraid of its color, smell, or texture?

For this project you will need: 3 ounce containers of different colored Play-Doh and a piece of white paper. Lets start by removing the Play-Doh from the container and squishing it between your fingers. Close your eyes and feel the texture of the Play-Doh and the way it seeps through your fingers.

Next, make a ball out of the Play-Doh. Don't worry if it's not perfect, we're not looking for perfection. Flatten the ball

on the table and make a big pancake out of it or if you want to make a pizza, then pizza it is. Now, place your hands over your nose and take a deep breath; smell that great wonderful unique smell that only Play-Doh has. Does it bring back any memories?

You're going to attempt to make a Play-Doh baby, so you might want to take a look at some baby photos of yourself or your children. One of the things you need to be aware of is that the one part of the baby that doesn't grow much compared to the rest of it's body is the HEAD. So, the head should be about a third of the entire length of the baby.

As you build your baby, take your time and don't panic. This isn't a race and you aren't going to be graded. If you find yourself breathing hard, remember to do the color breathing exercise.

Let's implement what we did when you drew the elephant. We looked at doing one of the drawings using our logic. I already mentioned to you that the head should be a third of the entire length of the baby, but ask yourself these questions: how many eyes should it have, how many fingers, how many ears? Remember to give it feet, toes, and eyebrows.

Give this baby as many details as possible, the more

details the better. You don't want to deprive your baby of any physical parts. Please put a diaper on it and you can even put some clothes on it as well or you can put it in a crib. You can even make twins.

Have fun!

Here is an example that my son Emilio created.

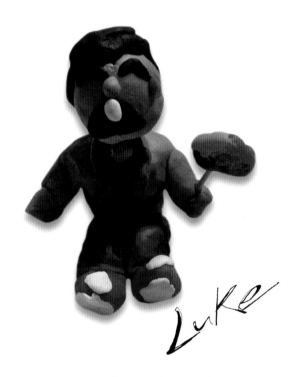

"Luke" © Emilió Silva, Age 14

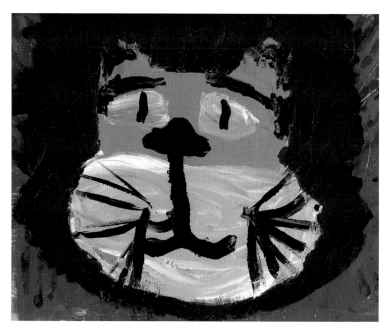

"Cat" © Emilió Silva, Age 9

*"I know something is super creative, when I feel
disappointed that I didn't come up with the idea!"*
- Simón Silva

*"Creativity can solve almost any problem.
The creative act, the defeat of habit by
originality, overcomes everything."*
- George Lois

Family Music Project

Most people assume that because I'm a visual artist most of my inspiration and ideas come from other artwork or visual artists and that's absolutely not true. Some of the best paintings I've created have been inspired by some of the movies, books, and music that I've been exposed to.

One of my favorite genres of music is Jazz, not the Kenny G Jazz, but what I consider to be spirit enriching Jazz. Music from the greats like Art Farmer, Blue Mitchell, Bill Evans, Miles Davis, and John Coltrane.

One of the projects that I've done with some of my students has been the Family Cd Project. A project that requires you to dig deep and think hard about music (songs)

that best describes each one of your family members. So I want you to get a piece of paper and think of the song that best describes each one of your family members and yourself.

Next , think of an overall theme for your cd, something like love or family. On the inside flap, I want you to write each family member's name followed by the song you chose for them. On the outer flap, I want you to create a cover (in color) for your music cd. I have provided you with a sample for you to examine.

Good luck, make it a great one and give it out to your family for Christmas or for their birthdays!

Mom - Porcupine Pie (Neil Diamond)
Dad - Love Sick prt. 3 (Nujabes)
Popas - Bliss Is Unaware (The Ocean Blue)
Nano - Sweet Honey (Slightly Stoopid)
Me - Someday (The Strokes)

"Dachshund" © Emilió Silva, Age 14

135

Play-Doh Self Portrait Project

Over the years I've done several self-portraits and each one of them has revealed a unique time period in my life. A time when the focus was on my cultural heritage, my religious beliefs, or when I was dealing with my past experiences. I will always prefer a hand painted portrait over a photograph because of the simple fact that photographs automatically have the tendency to highlight things about ourselves that we prefer not to be highlighted. Photos also have a tendency to distort things in ways that are never flattering, at least in my case.

The Self Portrait Project is a great way to help us slow down and be more observant. There's an endless amount

of materials that you can use in doing a self portrait but I recommend doing this using Play-Doh. It will not set fear or doubt running down your spine and I can guarantee you that this will help you be successful. You can start by finding either a small or a big mirror. I would even suggest one of those magnifying mirrors with a light, if possible. You can also use a baby photo or any photo that you prefer to work from.

Take your time and just look at your amazing face, the differences in the size of your eyes, the way that your nose might turn to one side or the other. Try to count the moles, scars, or any other significant beauty mark that you can find. Notice the changes in color in the different areas of your face. You might see tints and shades of reds, blues, greens, and yellows, depending on your skin color. Take some time and write down notes on what you noticed about your face.

Choose a couple of colors of Play-Doh and begin by making the face. Make sure you take the time to carefully figure out the shape of your face, is it round, square, or oval? Take a look at the sample that my son, Emilio, did and focus on how he carefully did the shapes of the eyebrows, the lips, and the nose.

The more detail the better. Make sure you pay attention

to all of the subtle differences; the angles of the eyebrows and the thickness of the lips.

Take a larger sheet of paper, if possible, and recreate the self portrait using color pencils this time. You will find it easier to do the self portrait with the color pencils now, since you've already done the Play-Doh version. Many students have found it difficult to do something if they start with the color pencils. The Play-Doh, being a non-threatening material, always makes it easier to maintain a creative flow.

You can do it!

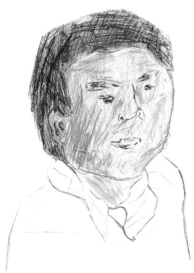

"Self Portrait" © Emilió Silva Age 11

No One Knows It All

One of the things that can help you maintain an open portal to your creative brain is to understand that we can learn something from everyone, regardless if they are young, old, educated, or not. I learned this the hard way.

I was tricked into speaking to a group of Kindergartners and First Graders, oh my! I make it a point not to speak to young kids because they scare me; their creativity scares me. So my nervous mind went into a protection mode and I lashed out by asking a somewhat demeaning question, "How many of you want to be artists when you grow up?" I looked around this large scary group and I noticed that there were no enthusiastic hands sticking up in the air. Instead,

I spotted kids picking their nose (possibly damaging their IQ's), some were fighting with their neighbors, some were falling asleep, but some were actually listening. I know this because I heard an angry, squeaky voice scream out at me "We're already artists!" I wasn't sure if this was a boy or a girl, since at that age they all sounded like Mickey Mouse on steroids.

Upon hearing this, my immediate thought was to run off stage and hide, but I decided to hold my ground and I began to apologize to this group of kids and I told them that I was very sorry to have asked that question. The correct question should have been, "How many of you want to be better artists when you grow up?" I knew that they were already fantastic artists.

When I was done, I humbly slipped out the back door embarrassed, yet enlightened by the wise words from a group of Kindergartners and First Graders.

Keep in mind that we can learn something from everyone because no one knows it all and no one ever will.

*"An essential aspect of creativity
is not being afraid to fail."*
- Edwin Land

"Clowns" © Josué Silva, Age 6

Family Portrait Project

It appears to me that people today are continuously filling up their minds with trivial information that doesn't lead to deep thought or contemplation. Learning how to be introspective is one of the ways that I've learned to nurture my creativity. This means putting in the time to read a novel, watch different genres of movies, listen to new music, and having a variety of intriguing conversations. These activities have nurtured my creative mind, motivating me to be more introspective and curious about my abilities.

Being able to clearly communicate our feelings, ideas, perspectives, and opinions should be one of our ultimate goals. By communicating clearly, we engage our audience

in ways that will produce better results whether it's in our creativity or our learning.

Knowing where you stand with your family and what you think of them is a wonderful opportunity to unlock your creativity. The Family Project will provide you with an opportunity to be introspective about your family, which I consider to be a wonderful source of inspiration both good and bad.

Create a family portrait using inanimate objects, insects or animals. Please don't use words or people, this would be too easy. Think about what it is that you want to say about your family: your mother, father, or siblings. You can address them as a group or individually. What is it that you want to say? Is it something good, controversial, something not so good?

If you're having a difficult time coming up with something visual I want you to think about which family member you want to build things around. Do you want to start with your father, your mother, one of your siblings, or maybe yourself? You might also want to take into consideration the type of work that your father or mother do or did, or try thinking of something that symbolically would represent your family members. For example, your father is represented by the

earth or the ground. Come up with a theme using food, animals, toys, or laundry. Keep in mind that color can add meaning to your image. Use color pencils or crayons, and if you're really brave, try doing this with a black ballpoint pen. Remember that the goal is not to create a great drawing but to come up with a creative representation (good or bad) of your family.

I've provided you with an image that my son Emilio created. Take a look at his description of what he came up with.

Good luck!

"Family Portrait" © Emilió Silva, Age 14
"The three cans of Play-Doh represent my brothers and I
The Orange hand on the left represents my dad (his favorite color)
The Purple hand on the right represents my mom (her favorite color)
Overall the image represents that my parents
are molding us into good citizens."

"Creativity takes courage."
- Henri Matisse

Object Placement Project

Where we place things on a page or a surface will determine the excitement that you create for the viewer and for yourself as a creative person. Take for example people who understand interior design or decorating. Where you place the couch or other objects will determine the dynamics of a room, how small or how big it will look. This will fuel the continuation of exploration and movement with anything you do, whether it's artistic in nature or not.

For this project you will need a piece of paper, a black ballpoint pen and two radically different size objects. For example, an orange and a grape. Study the sketches that I've provided for you. Sketch 1 is a typical placement that

doesn't have much excitement. It's safe, it's balanced but doesn't challenge the mind much. Sketch 2 is definitely better just by placing completely opposite sized shapes next to each other, but the view or perspective is still pretty bland, it's expected. However, Sketch 3 and 4 give us an unexpected view and a dynamic placement that energizes the space in which they're placed.

Try sketching small squares on your paper and try placing your objects within those spaces in a variety of ways. Do this with different objects and once you feel comfortable with two objects and you want a bigger challenge try doing this with three or four objects.

Don't be afraid of sketching with a black ballpoint pen. This will prevent you from erasing and help you loosen up. The lines you sketch shouldn't be perfect.

Remember to have fun with this and continuously ask yourself if your placement of objects look more or less dynamic? Is there an interesting tension?

Next time you're in a restaurant you can practice this by using the salt and pepper shakers plus the ketchup bottle, before your food arrives.

Sketch 1 Sketch 2

Sketch 3 Sketch 4

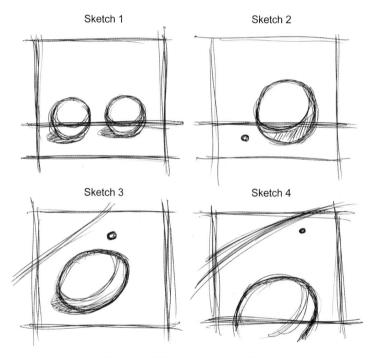

Placement Sketches © Simón Silva

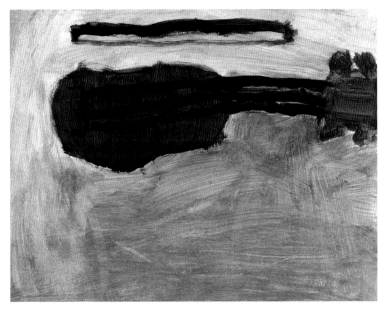

"The Violin" © Emilió Silva, Age 8

"The Violin"

Music is prominent in our home and I made a point to expose my kids to a variety of different genres of music. Musical instruments have also been around our house: guitars, compact pianos, a flute, trumpets, an old saxophone, always ready to be played. My wife's dream was for all of our kids to play music and eventually join the marching band at school, but it didn't happen.

One of my youngest son's friends was quite talented at playing the violin and seemed to enjoy playing his violin as well as showing it off. So, my son Emilio decided that he also wanted to play the violin. My wife and I were skeptical about his new found interest and decided to hold off on buying

him a violin. We figured that if we waited long enough his interest would fade away.

It was during this waiting period that Emilio decided to express his love and desire to play the violin the best way he knew how, through a painting.

He took a fresh canvas and began by covering the entire surface with a translucent sienna wash, leaving visible marks of the large brush he used. There's a gradual gradation of a darker sienna at the bottom right and it eventually gets lighter as it reaches the top of the painting.

When I look at this piece, I first get an impression that it's floating in the air, but then I get a feeling that it's resting on a table or a surface. The bow, placed on the side of the violin, creates a sense of preparedness. I also get the feeling of a married couple or a team resting, enjoying each others company.

The brush strokes used to paint the body of the violin have a controlled vertical direction, balancing the more erratic brush strokes of the background. I'm almost sure he used either one brush or two brushes to create this painting, which forced him to focus on the essence of the violin.

You can tell he didn't sketch this out first because he ran out of room for the neck of the violin but this wasn't an issue

in his mind; he just let it exit off the canvas gracefully. The open space at the bottom of the painting leads the eye back into the canvas. The use of two colors, black and brown, make the piece feel completely united.

Even though he used a large brush you can see his intention of making the strings on the bow lighter by the amount of pressure and paint he used.

The strings on the violin are incredibly interesting, being that they are incredibly thick, but they also have a bend to them that adds character and personality.

Needless to say, Emilio was incredibly successful not only in painting another masterpiece, but in convincing us to buy him the violin that he used for two weeks.

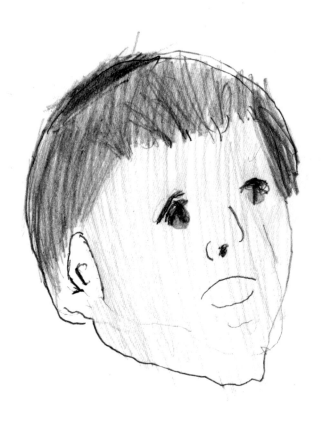

"Boy II" © Emilió Silva, Age 9

Cell Phone Project

As I travel around the country I continually find individuals unaware of the work that went into the design of the products they use everyday. When I mention that a product designer was paid to design their cell phones, cameras, coffee makers, blenders, and their smart pads, a blank stare is what I encounter.

What's even more alarming is that most students I encounter are completely unaware of how many things around them exist only because a designer/creative type brought it into existence. It's this type of ignorance that is holding us back and preventing us from moving forward with new inventions/creations. If more of our students were made

aware of things around them at an early age, I believe we would see a dramatic rise in inventions and improvements on old ones.

I decided to do something about this and came up with a project called the "Cell Phone Project." I created the Cell Phone Project to give individuals an opportunity to become aware of how creativity has impacted the evolution of technology.

Make a list of items you believe need to immediately change on all cell phones like battery life or durability. Make this list as long as you can. Also, make a list of capabilities you would like for your cell phone to have in the future.

There are two relatively new sciences that are happening right now: Biomimicry and Nano technology. If you're unaware of these two sciences, spend a bit of time looking them up and learning about some of the amazing scientific advances that are in the works.

Now, make a list of technology that was introduced to the world in Sci-fi or space theme movies like a light saber or holographic images. Movies have always been a wonderful source of inspiration for inventors/designers; they have inspired new creations that have yet to be invented.

Now, take a 3" x 3" yellow sticky or any piece of paper.

You might need to take a few color breaths before you begin this one just to get you loosened up and ready to create. Imagine it's 20 years into the future and you're in the market for an upgrade on your cell phone. Tell me about the cell phone you would like to be available or that you would invent. What is its name? How much does it cost? How does it work? Draw a small image of it. Don't worry about what your drawing looks like; what's important is your idea and your vision.

Take a look at the example that my son created in one of my workshops but don't you dare copy his idea. I know you can do better!

The Tattoo

• nano bots are injected beneath the skin from your wrist to your elbow

• nano bots light up in certain areas to form buttons, pictures etc.

• Wallpapers make it look like you have tattoos

"Tattoo Cell Phone" © 2013 Emilió Silva, Age 14

"Don't think. Thinking is the enemy of creativity. It's self-conscious, and anything self-conscious is lousy. You can't try to do things. You simply must do things."

\- Ray Bradbury

Elements Of The Arts

In my early semesters of art school I was introduced to the principles of design, as well as to the elements of the arts. These elements are a blue print that a creative person follows and considers when embarking on a creative journey. In a previous chapter I outlined the principles of design. I defined these elements as things that will help you create successful projects or simply a tool to critique your work or the work of others.

Whenever I get overwhelmed by a new project that I'm working on, I always make it a point to bring myself back to the basics. The basics will always help you get back on track on any project.

It was during my journey of public speaking that I began speaking about some of my personal experiences. I spoke about these things to try and make my presentations a bit more interesting. It was during these presentations that people began asking about the possibilities of a book, a compilation of my stories, my experiences. As an introvert I had never considered public speaking as a career, let alone becoming an author. The thought was exciting and scary all at the same time.

Me, write a book about my life and expose all of those embarrassing moments of myself? This sounded interesting but how was I to even start this project? I wondered if there was a secret to creating something like this. Did I have to take a class or hire someone to do this for me? I thought about this for awhile and I decided that I would begin this book project by using the elements of painting. I knew the order or process of constructing a painting, so I decided to use those same principles and follow the same process to write the book.

I began by asking myself what I wanted to say, this was the concept or idea. Next, I thought about the composition: was this going to be a novel or a collection of short stories or vignettes? I decided that I would do all of this by the use

of words instead of paints. It made sense to me that I could do this book project if I looked at writing as simply painting with words. I would add texture, line, lighting, and contrast through descriptive words.

I realized that writing would be less foreign to me by simply understanding that if I followed the Elements of the Arts, I would have a greater degree of understanding and success.

If you look at the chart on the next page and study the elements of the different art forms you will see the similarities of elements that flow through all the art forms. Keep this in mind as you embark on writing your next book or creating your next painting.

ELEMENTS OF PAINTING

Composition, Texture, Line,
Color, Lighting, Contrast

ELEMENTS OF WRITING

Theme, Character, Structure,
Setting, Point Of View,
Language and Style, Irony

ELEMENTS OF DANCE

Body, Action, Space,
Time, Energy

ELEMENTS OF MUSIC

Rhythm, Melody, Harmony,
Key, Texture, Form

"The secret to creativity is knowing how to hide your sources."

- Albert Einstein

Creative Prescription Project

Over the years I've experienced an abundance of fantastic movies, books, music, and conversations that have inspired my curiosity and stimulated my creativity. In many instances I've also experienced a sense of emotional healing and felt a surge of creative energy. I believe that if others gave themselves the opportunity to experience these things that they too, would heal, change, and be inspired.

For this project, pretend that you're an artistic (creative) healer; a person that uses their repertoire of artistic experiences to help heal and nurture emotional ailments. For example, if a friend called and said that he or she was feeling melancholic and uninspired, what I would do is

take out my artistic prescription pad and assign them the following remedy. Then have them call me in the morning.

Prescription For Melancholy:

Album/Music - *Kind Of Blue* by Miles Davis

Movie - *Cinema Paradiso* by Giuseppe Tornatore

Food - Albondiga Soup

Painting - *"Violets"* by Vincent Van Gogh

Book - *Love In The Time Of Cholera* by Gabriel Garcia Marquez

I would like for you to try and come up with an artistic prescription for Love, Happiness, Sadness, Loneliness and Anger.

Good Luck!

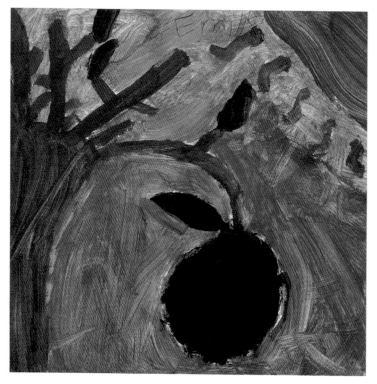

"Orange" © Emilió Silva, Age 10

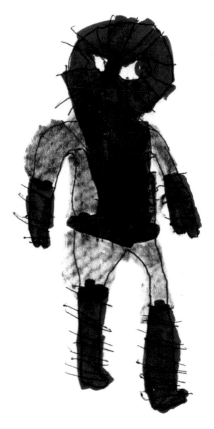

"Superhero" © Emilió Silva, Age 4

Nurturing Dynamic Communication Skills

A student recently asked me to explain my claim that creativity (the arts) produces dynamic communication. I first thanked him for the great question and asked him if he might have an idea of what I was referring to. He, unfortunately, didn't have much input or was just simply embarrassed that he was put on the spot.

I went on to explain my claim about enhanced communication by clarifying my view about culture, an important point that I've been talking about for many years now in my keynotes.

I don't believe that culture is necessarily about genetics, but a way of life; how you view the world; how you approach things; how you do things. I believe that we can acquire as many cultures as we want because culture is more than just great food and language. I also believe that multiculturalism is the future because it can offer us unique experiences, thoughts, and perspectives.

In order for me to define what "label" I identify with, I decided to integrate a couple of dynamic examples using a creative application of math and something organic.

My goal was to give a rich and personal explanation of my own cultural identification. Over the years my cultural association has gone from just plain American or Chicano to Mexican-American and currently standing at American-Mexican. This "label" came about from using math as a means to apply percentages to certain facts. For example, I was born in Mexico (10%), I was brought up in a traditional Mexican Family (10%) but I was educated in America. I was influenced by American pop culture and I dream in English, this was given 80%, thus ending up with American-Mexican.

However, I went on to explain, culture can also be something liquid. If I have a fantastic Mexican meal and I listen to some fantastic Mariachi music, the percentages

can shift from 80/20 to 60/40 or 40/60. I was able to view culture as something alive and organic.

By nurturing your creativity, you will develop a broader range of communication skills and an expanded view of seeing things. The fantastic thing about this is that it will happen without you even noticing.

"There is no doubt that creativity is the most important human resource of all. Without creativity, there would be no progress, and we would be forever repeating the same patterns."
— Edward de Bono

Images as Sounds

Have you ever heard the phrase, "that color is loud?" One of the ways that I've been able to help people understand balance and variety is by explaining to them that by looking at images as a sound we have another way of looking at things.

Let me explain, I'm sure that you've had boring teachers or professors that put you to sleep a few times because of their monotone lectures. I'm also sure that you've had some dynamic teachers/professors that have kept you awake by their screams and screeches. Neither one of these methods works because there is no balance or variety in their voice and delivery.

Being creative requires that we recognize the need for variety in size, shape, color, texture, and lines. In the same way that a monotonous conversation has an overuse of tone, it can also be possible that a drawing or painting has very little excitement for the same reasons when everything is the same.

Think about your voice. You can whisper, speak normal, scream, whistle, grunt, or be silent. What other noises can you make with your mouth?

Tear a piece of paper like you did in the previous chapter. Make some marks on that paper that represent different sounds. For example, a dot could be a whisper, a long thin line could represent a monotonous sound, a lightning bolt could be a scream, empty space can represent silence. See how many different sound representations you can come up with. This is incredibly valuable in any creative project. If you get stuck, try and communicate by adding sound to your image, using a whisper, a couple of screams, or a whistle.

Next time you look at a piece of art listen to what it is saying. Is it screaming or is it a boring conversation? Art is a fantastic mix of sights and sound.

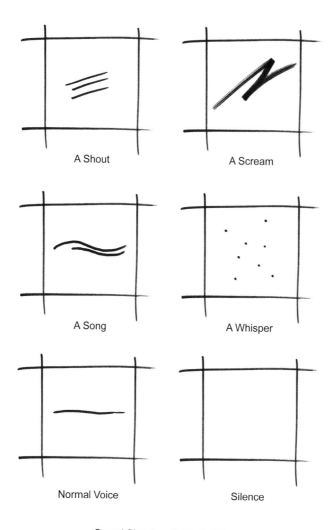

Sound Sketches © Simón Silva

Personal Survey

I have found it incredibly helpful and inspiring to acknowledge who I am by identifying what I enjoy and what I have experienced in my life. As I get older and my life experiences broaden, my likes and dislikes change. Our creativity can improve with age if we are willing to acknowledge our own life experiences.

The following page is a questionaire that will help reveal what you like and what is important to you. Be honest with your answers and only write down one answer, not two or three. This is something you should try to do at least once a year and you will see how your answers will change with time just like mine have changed over the years.

My name is (include middle names):

My goal in life is:

My favorite memory is:

My favorite love song is:

My favorite place to visit is:

My proudest moment is:

The thing I hate the most is:

The thing I love the most is:

Who has been your best teacher (why):

Who has been your worst teacher (why):

What is the best thing about your mom?

What is the best thing about your dad?

The perfect job would be:

My favorite movie is:

My inspiration is:

My life is:

My favorite food is:

How long would you like to live?

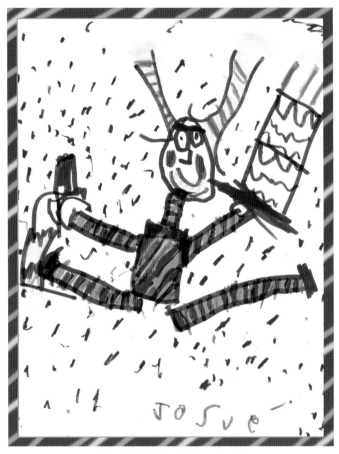

"Birthday" © Josué Silva, Age 5

*"The creative person wants to be a know-it-all.
He wants to know about all kinds of things:
ancient history, nineteenth-century mathematics,
current manufacturing techniques, flower
arranging, and hog futures. Because he never
knows when these ideas might come together to
form a new idea. It may happen six minutes later
or six months, or six years down the road.
But he has faith that it will happen."*
— Carl Ally

Final Thoughts

In a recent article written by Geoffrey Thomas called, "Ten Myths of Creativity" (http://bgthomas.com/articles/ten-myths-of-creativity/), Mr. Thomas makes a compelling case that creativity is something that doesn't happen by accident or that it's something that is strictly limited to a few gifted individuals. He points out studies that show creativity is something that is developed and nurtured by anyone who is willing to do so.

Reading this book is only going to make you aware of your creativity. The real growth will come from continuously practicing the projects in this book. These projects are only a handful of ways that you can start with. I'm confident that

once you develop your creativity you will have a desire to invent new and exciting projects. Speaking about new ideas and sharing creative experiences with other creative individuals will help maintain a healthy creative state of mind. The more I talk about my own creative ideas, the more exciting my pursuit becomes.

As a final send off on your creative journey I have compiled a list of movies, books, and music that have inspired my creative journey. This list is only a partial list since it continues to evolve as I add and delete items as I move forward in my journey. I am confident that this list will open new creative avenues and continue to help you cultivate a creative mind and regain creative confidence.

Glossary

List Of Inspirational Movies

Central Station

Slam

Were Once Warriors

Whale Rider

El Postino

Life is Beautiful

Cinema Paradiso

Blood in Blood Out

Los Olvidados

El Norte

My Left Foot

Boys N the Hood

Joyluck Club

Ballad of Gregorio Cortez

Como Agua Para Chocolate

White Rose

Pulp Fiction

Run Lola Run

Shindler's List

October Sky

Seven Samurai

Buena Vista Social Club

Shine

Amores Perros

Angela's Ashes

Finding Forrester

Requiem for a Dream

Ghost Dog

Matrix 1, 2, 3

El Abuelo

The Two of Us

Stand & Deliver

The Legend of 1900

I Am Sam

Vanilla Sky

Minority Report

Stone Writer

Crash

Born Into Brothels

March of the Penquins

Magnificent Seven

The Band's Visit

Gran Torino

Phoebe in Wonderland

Samurai II

Moon

Which Way Home

Mildred Pierce

The Boys of Baraka

Hidden Blade

Mountain Patrol

Half Nelson

Little Miss Sunshine

Everything Illuminated

Pretty Dirty Things

The Island

Dreams

Dodes Ka-Den

Ran

Rashomon

The Fog of War

Why We Fight

Who Killed the Electric Car?

Copying Beethoven

The Lost Boys

Sophie Scholl

When the Levees Broke

Tsotsi

Sorry Haters

Neverwas

Little Children

Perfume

Lions for Lambs

War Dance

The Namesake

Under the Same Moon

Deep Sea 3D

Starting out in the evening

Corporation

Dar Fur

Young At Heart

Kenny

Sleuth

2Pac - Resurrection

W.

God Grew Tired of Us

Slumdog Millionaire

Sin Nombre

Food, Inc.

Mother & Child

List Of Inspirational Movies (Continued)

Between The Folds

Romantico

Blackfish

The Cove

A Better Life

Blade Runner

Intouchables

Man On the Moon

Prometheus

The Imposter

Before Sunset

Beautiful Losers

Last Train Home

Liberal Arts

The Lone Ranger (2013)

The Three Burials of Melquides Estrada

Eternal Sunshine of The Spotless Mind

The Untold Story of Emmitt Louis Till

Cloudy With A Chance Of Meatballs

The Diving Bell & The Butterfly

The Wizard Of Oz

Star Wars (4, 5, 6)

Gravity

List Of Inspirational Music

Mana

Miles Davis

Caifanes

Pedro Infante

Mozart

Mendelson

U2

John Coltrane

Bob Marley

Rage Against The Machine

The Waterboys

Marvin Gaye

The Supremes

John Lennon

George Winston

Shakira (Songs in Spanish)

Average White Band

Ramon Ayala

Vivaldi

Elvis Presley

Stevie Wonder

James Brown

Billie Holiday

Sarah Vaughn

Clifford Brown

Roy Hargrove

Coleman Hawkins

The Beatles

Norah Jones

Javier Solis

The Shins (early stuff)

Josh Rouse

Andrew Bird

Bob Dylan

The Rolling Stones

Matisyahu

Ryan Adams

Wilco

ASA

Nujabes

Beck

Radiohead

Murs

Weezer

Nina Simone

List Of Inspirational Music (Continued)

2Pac

Fanfarlo

Esperanza Spalding

The Tallest Man On Earth

The Ocean Blue

Bill Evans

Freddie Hubbard

David Bowie

Rodriguez

JDilla

Irene Diaz

Dr. Yusef Lateef

Amos Lee

Average White Band

Neil Young

Brad Mehldau

Buddy Holly

ELO

Luis Bonfa

Shing02

The Smiths

Toad The Wet Sprocket

Wilco

List Of Inspirational Books

Bless Mi Ultima - Rudolfo Anaya

Invisible Man - Ralph Ellefson

Martin & Meditations On The South Valley - Jimmy Santiago Baca

Cien Años De Soledad - Gabriel Garcia Marquez

Rain Of Gold - Victor Villaseñor

Native Son - Richard Wright

House On Mango St. - Sandra Cisneros

White Rose - B. Traven

Chicana Falsa - Michelle Serros

The Freedom Writers Diary - Erin Gruwell

Drown - Junot Diaz

The Brief Wondrous Life of Oscar Wao - Junot Diaz

A Whole New Mind - Daniel H. Pink

Outliers - Malcolm Gladwell

Blink - Malcolm Gladwell

5 Minds For The Future - Harold Gardner

Moby Dick - Herman Melville

The Power Of Habit - Charles Duhigg

Art & Physics - Leonard Shlain

The Artist Way - Julia Cameron

Reality Hunger: A Manifesto - David Shields

Early Novels & Stories - James Baldwin

The Shallows - Nicholas G. Carr

NOTES

NOTES